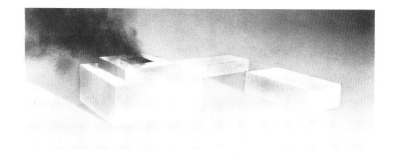

EDWARD RUSCHA
Cover
County Museum on Fire Study, 1965
Pencil on paper
6-1/8" x 12-7/8"
Courtesy the artist

Frontispiece
Museum on Fire, 1968
Graphite on paper
8" x 14-1/2"
Collection: Jean Pigozzi, New York

The Invisible Dragon

FOUR ESSAYS ON BEAUTY

BY DAVE HICKEY

Art issues. Press
Los Angeles

The Foundation for Advanced Critical Studies
8721 Santa Monica Boulevard, Suite 6
Los Angeles, California 90069

First Edition
Third Impression

Art issues. Press is a division of The Foundation for Advanced Critical Studies,
a nonprofit California corporation.

This publication has been made possible through the generous support of
Lannan Foundation, with additional funding provided by The Andy Warhol
Foundation for the Visual Arts and contributions from the public.

Designed by Linda Norlen

Manufactured in the United States of America

Library of Congress Cataloguing in Publication Number: 93-71886
International Standard Book Number: 0-9637264-0-4

For Libby

ACKNOWLEDGEMENTS

Since the essays in this book recount four excursions through an untraveled country well outside the landscape of contemporary criticism, I have taken the occasion of publishing them together to exploit this exotic appeal, rewriting them from my original notes, incorporating further speculation about the local flora and fauna. Unavoidably, however, since all these essays traverse the same lost place, they all intersect at one point or another. I can only apologize for the redundancy and hope that the experience of passing the same dry rock on four different journeys from four different directions might lend it a certain dimensionality. I would hope, further, that these points of intersection constitute the only cartography in these essays, since I have no wish to chart perimeters, only to keep moving and looking and thinking and writing, out of joy and anger, after the manner of my Victorian mentor, John Ruskin.

Rereading these essays in their present state, however, I detect several intransigent habits of mind which, since they are not specifically articulated in the text, should probably be acknowledged here. First, I have habitually suppressed the traditional contrariety of beauty and ugliness and of pleasure and pain in order to privilege all these extraordinary conditions over their true contrary: the banality of neutral comfort. This is, more or less, the point. Second, in discussions of the art market, you will find me adamantly and unfashionably disinclined to equate "commerce," which is characteristic of all human cultures, with "capitalism," which has plagued but a few. This is a matter of religion.

Otherwise, I would hope that these essays are largely driven by the antic engine of curiosity. They are fugitive critiques, and I write this in full knowledge of just how fugitive they are, since, excepting the impeccable Ruscha, the citizens whose lives and works inform these writings most profoundly have died during the period of their composition. So I would hope that this book might stand as a tiny monument to the memory of Andy Warhol and Robert Mapplethorpe and Michel Foucault—as a thank you to my friend Edward Ruscha for all the beauty and mystery—and as a testament, as well, to the kindness and acuity of Edmund Pillsbury and the staff of the Kimbell Art Museum in whose lovely spaces many of these speculations have their home.

Finally, I must acknowledge my gratitude to Gary Kornblau, editor de luxe, who must accept whatever blame accrues to the idea of gathering these fugitive essays together. His diligence and enthusiasm have proved deleterious to my cynicism, and his exceptional therapeutic institution, The Foundation for Advanced Critical Studies, is the exception that proves the rule.

A short synopsis of "Enter the Dragon" was published as "The Invisible Dragon" in *Parkett* #28 (Summer 1991), in Zurich. "Nothing Like the Son" had its genesis in a lecture entitled "On the Beautiful, the Sublime & the *X Portfolio*," delivered on February 8, 1992 at the Dallas Museum of Art, and again, in the summer of that year, at Art Center College of Design in Pasadena. "Prom Night in Flatland" began as a short essay entitled "Community Property and the Eye of the Beholder" in *Eau de Cologne* #3 (Winter 1989), in Cologne; it was reprinted in *Artspace* (July/August 1990), in Albuquerque. The original version of "After the Great Tsunami" was published as "A Cloud of Dragons" in *Art issues* #27 (March/April 1993), in Los Angeles.

He found it was as easy to hurl beauty
as anything else.
　　　　　　—Patti Smith on Robert Mapplethorpe

Contents

It would be nice if sometime a man
would come up to me on the street and say,
"Hello, I'm the information man, and you have
not said the word 'yours' for thirteen minutes.
You have not said the word 'praise' for eighteen
days, three hours, and nineteen minutes."
 —Edward Ruscha, *Information Man*

Enter the Dragon
ON THE VERNACULAR OF BEAUTY

I was drifting, daydreaming really, through the waning moments of a panel discussion on the subject of "What's Happening Now," drawing cartoon daggers on a yellow pad and vaguely formulating strategies for avoiding punch and cookies, when I realized that I was being addressed from the audience. A lanky graduate student had risen to his feet and was soliciting my opinion as to what "The Issue of the Nineties" would be. Snatched from my reverie, I said, "Beauty," and then, more firmly, "The issue of the nineties will be *beauty*"—a total improvisatory goof—an off-the-wall, jump-start, free-association that rose unbidden to my lips from God knows where. Or perhaps I was being ironic, wishing it so but not believing it likely? I don't know, but the total, uncomprehending silence that greeted this modest proposal lent it immediate credence for me.

My interlocutor plopped back into his seat, exuding dismay, and, out of sheer perversity, I resolved to follow beauty where it led into the silence. Improvising, I began updating Pater; I insisted that beauty was not a *thing*—"the beautiful" was a thing. In images, I intoned, beauty was the agency that caused visual pleasure in the beholder; and any theory of images that was not grounded in the pleasure of the beholder begged the question of their efficacy and doomed itself to inconsequence. This sounded provocative to me, but the audience continued to

sit there, unprovoked, and "beauty" just hovered there, as well, a word without a language, quiet, amazing and alien in that sleek, institutional space—like a Pre-Raphaelite dragon aloft on its leather wings.

"If images don't *do* anything in this culture," I said, plunging on, "if they haven't *done* anything, then why are we sitting here in the twilight of the twentieth century talking about them? And if they only do things after we have talked about them, then *they* aren't doing them, *we* are. Therefore, if our criticism aspires to anything beyond soft-science, the efficacy of images must be the cause of criticism, and not its consequence—the subject of criticism and not its object. And this," I concluded rather grandly, "is why I direct your attention to the language of visual affect—to the rhetoric of how things look—to the iconography of desire—in a word, to *beauty*!"

I made a *voilà* gesture for punctuation, but to no avail. People were quietly filing out. My fellow panelists gazed into the dark reaches of the balcony or examined their cuticles. I was genuinely surprised. Admittedly, it was a goof. Beauty? Pleasure? Efficacy? Issues of the Nineties? Admittedly outrageous. But it was an outrage worthy of a rejoinder—of a question or two–a nod—or at least a giggle. I had wandered into this *dead zone*, this silent abyss. I wasn't ready to leave it at that, but the moderator of our panel tapped on her microphone and said, "Well, I guess that's it, kids." So I never got off my parting shot. As we began breaking up, shuffling papers and patting our pockets, I felt a little sulky. (Swallowing a pithy allusion to Roland Barthes can do that.) And yet, I had no sooner walked out of the building and into the autumn evening than I was overcome by this strange Sherlock Holmesian elation. The game was afoot.

I had discovered something; or rather, I had put out my hand and discovered nothing—this vacancy that I needed to understand. I had assumed that from the beginning of the sixteenth century until just last week artists had been persistently

and effectively employing the rough vernacular of pleasure and beauty to interrogate our totalizing concepts "the good" and "the beautiful;" and now this was over? Evidently. At any rate, its critical vocabulary seemed to have evaporated overnight, and I found myself muttering detective questions like: Who wins? Who loses? *Qui bono?*—although I thought I knew the answer. Even so, for the next year or so, I assiduously trotted out "beauty" wherever I happened to be, with whomever I happened to be speaking. I canvassed artists and students, critics and curators, in public and in private—just to see what they would say. The results were disturbingly consistent, and not at all what I would have liked.

Simply put, if you broached the issue of beauty in the American art world of 1988, you could not incite a conversation about rhetoric—or efficacy—or pleasure—or politics—or even Bellini. You ignited a conversation about the market. That, at the time, was the "signified" of beauty. If you said "beauty," they would say, "The corruption of the market," and I would say, "The corruption of the *market*?!" After thirty years of frenetic empowerment, during which the venues for contemporary art in the United States had evolved from a tiny network of private galleries in New York into this vast, transcontinental sprawl of publicly-funded, post-modern ice-boxes? During which time the ranks of "art professionals" had swollen from a handful of dilettantes on the east side of Manhattan into this massive civil service of PhDs and MFAs who administered a monolithic system of interlocking patronage, which, in its constituents, resembled nothing so much as that of France in the early nineteenth century? While powerful corporate, governmental, cultural, and academic constituencies vied for power and tax-free dollars, each with its own self-perpetuating agenda and none with any vested interest in the subversive potential of visual pleasure? Under *these* cultural

conditions, artists across this nation were obsessing about the *market?*—fretting about a handful of picture-merchants nibbling canapes on the Concorde?—blaming them for any work of art that did not incorporate raw plywood?

Under these cultural conditions, I would suggest, saying that "the market is corrupt" is like saying that the cancer patient has a hangnail. Yet the manifestations of this pervasive *idée fixe* remain everywhere present today, not least of all in the sudden evanescence of the market itself after thirty years of scorn for the intimacy of its transactions, but also in the radical discontinuity between serious criticism of contemporary art and that of historical art. At a time when easily sixty percent of historical criticism concerns itself with the influence of taste, patronage, and the canons of acceptability upon the images that a culture produces, the bulk of contemporary criticism, in a miasma of hallucinatory denial, resolutely ignores the possibility that every form of refuge has its price, satisfies itself with grousing about "the corruption of the market." The transactions of value enacted under the patronage of our new, "non-profit" institutions are exempted from this cultural critique, presumed to be untainted, redemptive, disinterested, taste-free, and politically benign. Yeah, right.

During my informal canvass, I discovered that the "reasoning" behind this presumption is that art dealers "only care about how it looks," while the art professionals employed by our new institutions "really care about what it means." Which is easy enough to say. And yet, if this is, indeed, the case (and I think it is), I can't imagine any but the most demented *naif* giddily abandoning an autocrat who monitors appearances for a bureaucrat who monitors desire. Nor can Michel Foucault, who makes a variation of this point in *Surveiller et punir*, and poses for us the choice that is really at issue here, between bureaucratic surveillance and autocratic punishment. Foucault opens his book with a grisly, antique text describing the lengthy public torture and ulti-

mate execution of Damiens, the regicide; he then juxtaposes this cautionary spectacle of royal justice with the theory of reformative incarceration propounded by Jeremy Bentham in his "Panopticon."

Bentham's agenda, in contrast to the king's public savagery, is ostensibly benign. It reifies the benevolent passion for secret control that informs Chardin's pictorial practice, and, like Chardin, Bentham *cares*. He has no wish to punish the offender, merely to reconstitute the offender's desire under the sheltering discipline of perpetual, covert, societal surveillance in the paternal hope that, like a child, the offender will ultimately internalize that surveillance as a "conscience" and start controlling himself as a good citizen should. However, regardless of Bentham's ostensible benignity (and, in fact, because of it), Foucault argues that the king's cruel justice is ultimately more just—because the king does not care what we *mean*. The king demands from us the appearance of loyalty, the rituals of fealty, and, if these are not forthcoming, he destroys our bodies, leaving us our convictions to die with. Bentham's warden, on the other hand, demands our *souls*, and on the off chance that they are not forthcoming, or *cannot* come forth into social normality, he knows that we will punish ourselves, that we will have internalized his relentless surveillance in the form of self-destructive guilt.

These are the options that Foucault presents us; and I would suggest that, within the art community, the weight of the culture is so heavily on Bentham's side that we are unable to see them as equally tainted. We are, I think, such obedient children of the Panopticon, so devoted to care, and surveillance, and the redeemable *souls* of things, that we have translated this complex, contemporary option between the king's savage justice and Bentham's bureaucratic discipline into a progressive, utopian choice between the "corrupt old market" and the "brave new institution." Thus beauty has become associated with the "corrupt old market" because art dealers, like Foucault's king, traf-

fic in objects and appearances. They value images that promise pleasure and excitement. Those that keep their promise are admitted into the presence of the court; those that fail are subject to the "king's justice," which can be very cruel and autocratic indeed. But there is another side to this coin, since art dealers are also like Foucault's king in that they do not care "what it means." Thus radical content has traditionally flourished under the auspices of this profound disinterest.

The liberal institution, however, is not so cavalier about appearances as the market is about meaning. Like Jeremy Bentham's benevolent warden, the institution's curators hold a public trust. They must look carefully and genuinely care about what artists "really" mean—and therefore they must, almost of necessity, distrust appearances—distrust the very idea of appearances, and distrust most of all the appearance of images that, by virtue of the pleasure they give, are efficacious in their own right. The appeal of these images amounts to a kind of ingratitude, since the entire project of the new institution has been to lift the cruel burden of efficacy from the work of art and make it possible for artists to practice that "plain honesty" of which no great artist has yet been capable, nor ever wished to be. Yet, if we would expose the inner soul of things to extended public scrutiny, "sincere" appearance is everything, and beauty is the *bête noire* of this agenda, the snake in the garden. It steals the institution's power, seduces its congregation, and, in every case, elicits the dismay of artists who have committed themselves to plain honesty and the efficacy of the institution.

The arguments these artists mount to the detraction of beauty come down to one simple gripe: *Beauty sells*, and although their complaints usually are couched in the language of academic radicalism, they do not differ greatly from my grandmother's *haut bourgeois* prejudices against people "in trade" who get their names "in the newspaper." Beautiful art *sells*. If it sells itself, it is an idolatrous commodity; if it sells anything else, it is

a seductive advertisement. Art is not idolatry, they say, nor is it advertising, and I would agree—with the caveat that idolatry and advertising are, indeed, art, and that the greatest works of art are always and inevitably a bit of both.

Finally, there are issues worth advancing in images worth admiring; and the truth is never "plain," nor appearances ever "sincere." To try to make them so is to neutralize the primary, gorgeous eccentricity of imagery in Western culture since the Reformation: the fact that it cannot be trusted, that imagery is always presumed to be proposing something contestable and controversial. This is the sheer, ebullient, slithering, dangerous fun of it. No image is presumed inviolable in our dancehall of visual politics, and all images are potentially powerful. Bad graphics topple good governments and occlude good ideas; good graphics sustain bad ones. The fluid nuancing of pleasure, power and beauty is a serious, ongoing business in this culture and has been since the sixteenth century, when the dazzling rhetorical innovations of Renaissance picture-making enabled artists to make speculative images of such authority that power might be successfully bestowed upon them, privately, by their beholders, rather than (or at least prior to) its being assigned by the institutions of church and state.

At this point, for the first time in history, the power of priestly and governmental bureaucracies to assign meaning to images began to erode, and the private encounter between the image and its beholder took on the potential of changing the public character of institutions. Images became mobile at this point, and irrevocably political—and henceforth, for more than four centuries subsequent to the rise of easel painting, images *argued* for things—for doctrines, rights, privileges, ideologies, territories, and reputations. For the duration of this period, a loose, protean collection of tropes and figures signifying "beauty" functioned

as the *pathos* that recommended the *logos* and *ethos* of visual argumentation to our attention. It provided the image's single claim to being looked at—and to being believed. The task of these figures of beauty was to enfranchise the audience and acknowledge its power—to designate a territory of shared values between the image and its beholder and, then, in this territory, to argue the argument by valorizing the picture's problematic content. Without the urgent intention of reconstructing the beholder's view of things, the image had no reason to exist, nor any reason to be beautiful. Thus, the comfort of the familiar always bore with it the *frisson* of the exotic, and the effect of this conflation, ideally, was persuasive excitement—visual pleasure. As Baudelaire says, "the beautiful is always strange," by which he means, of course, that it is always strangely familiar.

Thus Caravaggio, at the behest of his masters, would deploy the exquisite hieratic drama of *The Madonna of the Rosary* to lend visual appeal and corporeal authority to the embattled concept of the intercession of the priesthood—and would demonstrably succeed, not only in pleading his masters' case, but in imposing the urbane glamour of his own argument onto that doctrine. So today, as we stand before *The Madonna of the Rosary* in Vienna, we pay homage to a spectacular souvenir of successful visual litigation—an old warhorse put out to pasture— in this case, a thoroughbred. The image is quiet now; its argumentative *frisson* has been neutralized, and the issue itself drained of ideological urgency, leaving only the cosmetic superstructure of that antique argument just visible enough to be worshipped under the frayed pennants of "humane realism" and "transcendent formal values" by the proponents of visual repose.

Before we genuflect, however, we must ask ourselves if Caravaggio's "realism" would have been so trenchant or his formal accomplishment so delicately spectacular, had his contemporary political agenda, under the critical pressure of a rival Church, not seemed so urgent? And we must ask ourselves fur-

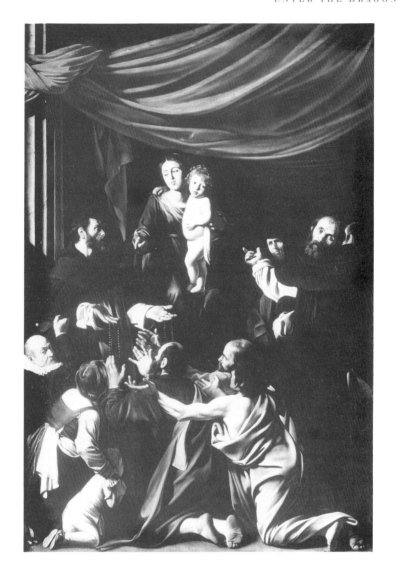

CARAVAGGIO
Madonna of the Rosary, 1606-7
Oil on canvas
143-3/8" x 98"
Courtesy Kunsthistorisches Museum, Vienna

ther if the painting would have even survived until Rubens bought it, had it not somehow expedited that agenda? I doubt it. We are a litigious civilization and we do not like losers. The history of beauty, like all history, tells the winner's tale; and that tale is told in the great mausoleums where images like Caravaggio's, having done their work in the world, are entombed—and where, even hanging in state, they provide us with a ravishing and poignant visual experience. One wonders, however, whether our standards for the pleasures of art are well founded in the glamorous *tristesse* we feel in the presence of these institutionalized warhorses, and whether contemporary images are really enhanced by being institutionalized in their infancy, whether there might be work in the world for them to do, as well.

For more than four centuries, the idea of "making it beautiful" has been the keystone of our cultural vernacular— the lover's machine-gun and the prisoner's joy—the last redoubt of the disenfranchised and the single direct route from the image to the individual without a detour through church or state. Now, it seems, that lost generosity, like Banquo's ghost, is doomed to haunt our discourse about contemporary art—no longer required to recommend images to our attention or to insinuate them into the vernacular—and no longer even welcome to try. The route from the image to the beholder now detours through an alternate institution ostensibly distinct from church and state. Even so, it is not hard to detect the aroma of Caravaggio's priests as one treads its gray wool carpets or cools one's heels in its arctic waiting rooms. One must suspect, I think, that we are being denied any direct appeal to beauty, for much the same reason that Caravaggio's supplicants were denied appeal to the Virgin: to sustain the jobs of bureaucrats. Caravaggio, at least, *shows* us the Virgin, in all her gorgeous autonomy, before instructing us not to look at her and redirecting our guilty eyes to that string of wooden beads hanging from the priest's fingers. The priests of the new church are not so generous. Beauty, in their domain, is altogether else-

where, and we are left counting the beads and muttering the texts
of academic sincerity.

As luck would have it, while I was in the midst of my
informal survey, the noisy controversy over exhibiting Robert
Mapplethorpe's erotic photographs in public venues provided me
with a set-piece demonstration of the issues—and, at first, I was
optimistic, even enthusiastic. This uproar seemed to be one of
those magic occasions when the private visual litigation that
good art conducts might expand into the more efficacious litiga-
tion of public politics—and challenge some of the statutory
restrictions on the conduct that Robert's images celebrate. I was
wrong. The American art community, at the apogee of its power
and privilege, chose to play the ravaged virgin, to fling itself pros-
trate across the front pages of America and fairly dare the fas-
cist heel to crush its outraged innocence.

Moreover, this community chose to ignore the specific
issues raised by Robert's photographs in favor of the "higher pol-
itics." It came out strenuously in defense of the status quo and
all the perks and privileges it had acquired over the last thirty
years, and did so under the tattered banner of "free expression"—
a catch phrase that I presumed to have been largely discredited
(and rightly so) by the feminist critique of images. After all, once
a community acquiesces in the assumption that *some* images are
certifiably toxic, this, more or less, "opens the door," as they say
in the land of litigation.

And finally, hardly anyone considered for a moment
what an incredible rhetorical *triumph* the entire affair signified.
A single artist with a single group of images had somehow man-
aged to overcome the aura of moral isolation, gentrification and
mystification that surrounds the practice of contemporary art in
this nation and directly threaten those in actual power with his
celebration of marginality. It was a fine moment, I thought, and

all the more so because it was the *celebration* and not the marginality that made these images dangerous. Simply, it was their rhetorical acuity, their direct enfranchisement of the secular beholder. It was, exactly, their beauty that had lit the charge—and, in this area, I think, you have to credit Senator Jesse Helms, who, in his antediluvian innocence, at least saw what was there, understood what Robert was proposing, and took it, correctly, as a direct challenge to everything he believed in. The Senator may not know anything about art, but rhetoric is his business and he did not hesitate to respond to the challenge. As, one would hope, he had a right to. Art is either a democratic political instrument, or it is not.

So, it was not that men were making it in Robert's images. At that time they were regularly portrayed doing so on the walls of private galleries and publicly funded "alternative" spaces all over the country. On account of the cult of plain honesty and sincere appearance, however, they were not portrayed as doing so *persuasively.* It was not that men were making it, then, but that Robert was "making it beautiful." More precisely, he was appropriating a Baroque vernacular of beauty that predated and, clearly, outperformed the puritanical canon of visual appeal espoused by the therapeutic institution. This canon presumes that we will look at art, however banal, because looking at art is, somehow, "good" for us, regardless and, ultimately, in spite of whatever specific "good" the individual work or artist might urgently propose to us.

This habit of subordinating the artist's "good" to the "higher politics of expression," of course, makes perfect sense in the mausoleums of antiquity where it was born, and where we can hardly do otherwise—where it is, perhaps, "good" for us to look at *The Madonna of the Rosary* without blanching at its Counter Reformation politics, because those politics are dead—and where it may be "good" for us, as well, to look at a Sir Thomas Lawrence portrait and "understand" his identification of

romantic heroism with landed aristocracy. It is insane and morally ignorant, however, to confront the work of a living (and, at that time, dying) artist as we would the artifacts of lost Atlantis, with forgiving connoisseurship—to "appreciate" his passionate, partisan, and political celebrations of the American margin—and in so doing, refuse to engage their "content" or argue the arguments that deal so intimately with trust, pain, love, and the giving up of the self.

Yet this is exactly what was expected and desired, not by the government, but by the art establishment. It was a matter of "free expression," and thus, the defense of the museum director prosecuted for exhibiting the images was conducted almost completely in terms of the redemptive nature of formal beauty and the critical nature of surveillance. The "sophisticated" beholder, the jury was told, responded to the elegance of the form regardless of the subject matter. Yet this beholder must be "brave" enough to look at "reality" and "understand" the sources of that formal beauty in the artist's tortured private pathology. If this sounds like the old patriarchal do-dah about transcendent formal values and humane realism, it is, with the additional fillip that, in the courts of Ohio, the sources of beauty are now taken to be, not the corruption of the market, but the corruption of the *artist*. So, clearly, all this litigation to establish Robert Mapplethorpe's "corruption" would have been unnecessary had his images somehow *acknowledged* that corruption, and thus qualified him for our forgiveness. But they did not.

There is no better proof of this, I think, than the fact that, while the Mapplethorpe controversy was raging, Francis Bacon's retrospective was packing them in at the Los Angeles County Museum of Art, and Joel-Peter Witkin was exhibiting in institutional serenity—because Bacon's and Witkin's images speak a language of symptoms that is profoundly tolerable to the status quo. They mystify Mapplethorpe's content, aestheticize it, personalize it, and ultimately further marginalize it as "artistic

behavior," with signifiers that denote angst, guilt, and despair. It is not portrayal that destabilizes, it is *praise*. Nor is it criticism of centrality that changes the world. Critique of the mainstream ennobles the therapeutic institution's ostensible role as shadow government and disguises its unacknowledged mandate to neutralize dissent by first ghettoizing it, and then mystifying it. Confronted by images like Mapplethorpe's that, by virtue of their direct appeal to the beholder, disdain its umbrella of "care," the therapeutic institution is immediately disclosed for what it is: the moral junkyard of a pluralistic civilization.

Yet the vernacular of beauty, in its democratic appeal, remains a potent instrument for change in this civilization. Mapplethorpe uses it, as does Warhol, as does Ruscha, to engage individuals within and without the cultural ghetto in arguments about what is good and what is beautiful. And they do so without benefit of clergy, out in the street, out on the margin where we might, if we are lucky, confront that information man with his reminder that we have not used the word "praise" for eighteen days, three hours, and nineteen minutes.

When I think of what sort of person
I would most like to have on retainer,
I think it would be a boss.
—Andy Warhol, *The Philosophy*

Nothing Like the Son

ON ROBERT MAPPLETHORPE'S *X PORTFOLIO*

I spent five minutes at the outside glancing through his images for defensible allusions to other works of art. I came up with Leonardo, Correggio, Raphael, Bronzino, Caravaggio, Ribera, Velázquez, Chardin, Reynolds, Blake, Gérôme, Fantin-Latour, and a bunch of photo guys. An art historian could doubtless do better, but would probably come to the same conclusion: These images are too full of art to be "about" it. They may live in the house of art and speak the language of art to anyone who will listen, but almost certainly they are "about" some broader and more vertiginous category of experience to which art belongs— and that we rather wish it didn't.

Consider Caravaggio's *The Incredulity of Saint Thomas* (1601). With its background cloaked in darkness and its space pitched out into the room, the painting recruits us to be complicit spectators as the resurrected Christ calmly grasps the incredulous Thomas by the wrist and guides the saint's extended forefinger into the wound in his side. Two other disciples crowd forward, leaning over Thomas' shoulder to observe more closely; and we are lured forward as well, by the cropped, three-quarter-length format of the painting that, like a baroque zoom, or like Christ's hand on our wrist, gently but firmly draws us into the midst of the spectacle. So, just as Christ opens his wound to Saint

Thomas, Caravaggio (presuming to persuade us from our doubt and lack of faith) opens that scene to us, in naturalistic detail. And we, challenged and repelled by the artist's characterization of us as incredulous unbelievers (and guilty in the secret knowledge that, indeed, we are), must respond with honor, with trust, by *believing*—and not, like Thomas, our eyes. (*To look* is to doubt.) So, to free ourselves from guilt, and from Caravaggio's presumption of our incredulity, we transcend the gaze, see with our hearts and acquiesce to the gorgeous authority of the image, extending our penitential love and trust to Christ—to the Word— to the painting—and ultimately, to Caravaggio himself.

Thus do the "religion of Christ" and the "religion of Art" erotically infect one another in our complex encounter with the image and the Word. For, just as Christ trusts Saint Thomas and suffers himself to be intimately touched, we trust the image and suffer ourselves to be touched as well—taking beauty as the signature of its grace and beneficence. And just as Christ, by his submission, ennobles his disciple and controls him, so we, by our submission, ennoble the image and control it. In doing so, we demonstrate that, even though we may be, in all other respects, nothing like the Son, we may still, like him, give ourselves up, trust ourselves to be humbled—by God, by art, by others—and, full of guilt, contract the conditions of our own submission—and in that submission redeem our guilt and dominate, triumph before the arrested image of our desire, in an exquisite, suspended moment of pleasure and control.

Or so Robert would have had you believe, he who began in the bosom of the Church and left it to rig out his own language of redemption on the street—a sleek patois of "classical" and "kitsch" that flirted with the low and disarmed the high with charm. Over the years, he would cultivate this dialect of tawdry beauty, refine it to the point of transparency and extend the fran-

chise of his work beyond the purview of the art world and its institutions. Then, at last, when those institutions of culture deigned to gather him in, those transparent images overrode all institutional disclaimers and continued to make accessible that which they had been making accessible all along. Very straightforwardly. People were shocked, and Robert died, leaving us with a repertoire of images that are as hard to ignore as they are impossible to misconstrue.

The images were all about transgression, of course, about paying for it in advance with the suspension of desire—and loving it. But they were not about transgression for its own sake. Those whom the world would change must change the world, and Robert's entire agenda, I think, derived from his understanding that, if one would change the world with art, one must change a great deal of it. Thus, the axiom that *the meaning of a sign is the response to it* had, for him, a quantitative as well as a qualitative dimension. He wanted them all—all those beholders—and wanting them, he saw the art world for what it was—another closet.

It was not enough for him that his images meant well— that they enfranchised "the quality" (although he hoped they would)—they must also mean *a lot*, for good or ill—because when push came to shove, the actual power to tip the status quo could only be bestowed upon images by representatives of that status quo, in the street and in the corridors of power. So he embarked upon a dangerous flirtation, but he was a man for that, and sailing as close to the wind as Wilde, he embraced the double irony of full disclosure and made the efficacy of his images a direct function of their power to enfranchise the non-canonical beholder—to enfranchise, ultimately, that Senator from North Carolina and insist upon his response—because, in truth, if the Senator didn't think an image was dangerous, it wasn't. Regardless of what the titillated cognoscenti might flatter themselves by believing, if you dealt in transgression, insisted upon it, it was

always the Senator, *only* the Senator, the Master of Laws, that Father, whose outrage really mattered.

I saw Robert's *X* images for the first time scattered across a Pace coffee table at a coke dealer's penthouse on Hudson Street, and in that context they were just what they would be—a sheaf of piss-elegant snapshots, mementos and naughty bits— photos the artist made when he wasn't making art, *noir* excursions into metaphysical masochism and trading cards for cocaine. As long as they existed in private circulation, they would

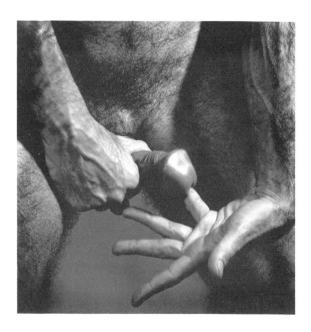

ROBERT MAPPLETHORPE
Lou, N.Y.C., 1978
Copyright © 1978 The Estate of Robert Mapplethorpe

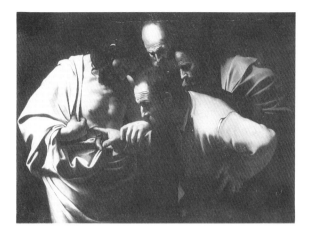

CARAVAGGIO
The Incredulity of St. Thomas (copy)
Galleria degli Uffizi, Florence
Courtesy Alinari/Art Resource, NY

remain so: handsome and disturbing images, to be sure, but clandestine artifacts, nevertheless, and peripheral texts at best— like Joyce's diaries or Delacroix's erotica. Today the images in *The X Portfolio* are "fine photographs" and better for it. They hang as authorized images in the oeuvre alongside their pornological predecessors and ancillaries, and that work is richer and rougher for their company.

Even so, hanging there on the wall amidst their sleeker siblings, these images seem so contingent, their "artistic" legitimacy so newly won that you almost expect to see sawdust on the floor. They seem so obviously to have come from someplace else, down by the piers, and to have brought with them, into the world of ice-white walls, the aura of knowing smiles, bad habits, rough language, and smoky, crowded rooms with raw brick walls, saw-horse bars and hand-lettered signs on the wall. They may be legitimate but, like my second cousins, Tim and Duane, they are

far from respectable, even now. Family and friends divide along lines of allegiance to them and will doubtless continue to; and it is this family feud, I think, rather than any parochial outcry over their content, that defines the difficulty of *The X Portfolio* images. For the real, largely unarticulated questions surrounding them, I would suggest, derive less from what they show about sex than from what they say about art—if they *are* art—and even Robert's putative supporters seem willing, on appropriate occasions, to assign them to second-class citizenship in the oeuvre.

It is an antique quarrel, really, dating from the dawn of the Baroque—and if I may draw a comparison without implying an equation, let me suggest that these *noir* photographs bear the same relationship to the rest of Robert's work that Shakespeare's *Sonnets* do to the body of his endeavor. Certainly *The Sonnets*, like the *X* images, have persistently served as a watershed for criticism, separating the sheep from the goats, as it were—and, if we believe (as there is every reason to) that the Quarto edition of *The Sonnets* was indeed suppressed, they have done so from the outset. In any case, throughout their four-hundred-year vogue, these poems have been cited alternately as Shakespeare's crowning laurel or as evidence of his feet of clay—with no lesser lights than Dr. Johnson, Coleridge, Wordsworth, Byron, and Bernard Shaw opting for the latter and offering some version of Henry Hallam's famous plaint that "it is impossible not to wish that Shakespeare had not written them"—a sentiment with which anyone who has been privy to discussions of *The X Portfolio* among "connoisseurs of fine photography" is doubtless familiar.

Both *The Sonnets* and *The X Portfolio*, it seems, suffer and benefit in equal parts from their taint of marginal legitimacy. The fact that both projects are bastard children, initially conceived in the intimacy of private discourse and only subsequently elevated in status, has persistently aroused suspicions that their formal exigencies and perfervid intensities are less the product of "artistry" than a by-product of their suboptimal secular agen-

das, which—on the candid evidence of the texts and images—
involved some thoroughgoing, non-fictional sexual improprieties
on the part of the Artist and the Bard. Depending on the com-
mentator, of course, these candid disclosures have either illu-
minated the more public production or infected that production
with an extra-textual aura of feverish disquiet. So the quarrel
continues. But it would not continue quite so strenuously, I think,
nor the issues of legitimacy and sexual impropriety seem quite so
critical, if the works in question were not so self-enclosed—if
there were some "outside" position, some discrete "cultural" van-
tage-point from which we might attend them. But there is not.
Like *The Incredulity of Saint Thomas*, both *The Sonnets* and *The X
Portfolio* compel our complicity, and characterize us, in the act of
attention, in some relatively uncomfortable ways.

In a typical sonnet, for instance, the actual William
Shakespeare addresses his actual mistress (of whatever gender)
and characterizes their relationship in one of two ways. He either
describes his mistress to "herself" (*"For I have sworn thee fair
and thought thee bright,/ who art as black as hell and dark as
night."*) or he describes himself to his mistress (*"Being your slave,
what could I do but tend/ upon the hours and times of your
desire?"*). As a consequence, the binary roles that the sonnet
makes possible—those of speaker and spoken to, beholder and
beheld, describer and described, dominant and submissive—are
all spoken for. They are exhausted and enclosed in the primary,
binary transaction between the poet and his mistress, an enclo-
sure whose rapt obsessiveness is succinctly demonstrated by a
quatrain from *Sonnet XXIV*:

> Now see what good turns eyes for eyes have done:
> Mine eyes have drawn thy shape, and thine for me
> Are windows to my breast, wherethrough the sun
> Delights to peep, to gaze therein on thee.

Here, excepting the Caravaggesque light-source, there is
no external reference, no neutral position outside the transaction

from which we may attend it. The words we hear are being spoken by a real person to a real person; the images we see are being shown by someone Other to someone else more Other still, and both are intertwined in the act of beholding. There is simply no allowance made in the rhetorical situation for an "objective cultural auditor"—which is not to say, of course, that we cannot *invent* one, only that it is nearly impossible to do so without entering into uneasy complicity with one participant or the other in the actual, factual narrative of desire of which the language is a trace. In other words, we have to trust someone, give ourselves up somehow to one position or the other.

What I am suggesting, of course, by this little discourse on the contingent rhetoric of *The Sonnets*, is that our relationship to the photographs in *The X Portfolio* is easily as problematic. The role of "objective cultural auditor" that we presume to inhabit—on account of the physical presence of the photograph in the gallery—may not indeed exist, since there can be little doubt that the arrested images in these dark photographs, like those in *The Sonnets,* are traces of lost erotic transactions in which the lover describes his mistress to his mistress, or describes himself to "her," and freezes that moment of apprehension as a condition of their intercourse. Thus all of the rhetorical positions implied by the photographs are exhausted in the suspended transaction between *beholder* and *beheld*—and the comfortable role of "art beholder" is written out of the scenario, as we are cast in roles before the image that we are unaccustomed to acknowledging—at least in public.

All of which would tend to confirm the veiled suspicions of those commentators who have approached *The X Portfolio* like church ladies at La Scala, exuding sophistication but wary of seduction, anxious about their pleasure and fearful of being manipulated to sexual rather than cultural ends by the flagrant ornamental display, suspicious that the "formal armature" of the imagery has been tainted somehow by its origins in situa-

tional erotics. This anxiety, it seems to me, is perfectly justified, although the offending double-entendre is hardly deplorable. It is, in fact, absolutely irremediable and, more or less, the point. The erotic and aesthetic potential of Robert's images derive from *exactly* the same rhetorical language and iconographic display, just as they do in Titian's *Venus d'Urbino*, and beyond the proclivity of the beholder, there is no way of sorting them out. They amount to no more (or less) than alternate readings that are as inextricably intertwined in our perception of them as are the spiritual and aesthetic rhetorics of *The Incredulity of Saint Thomas* (which are intertwined as well with a rather queasy, necrophilic subtext).

Simply put, the rituals of "aesthetic" submission in our culture speak a language so closely analogous to those of sexual and spiritual submission that they are all but indistinguishable when conflated in the same image. Or, to state the case historically: we have, for nearly a hundred years, hypostasized the rhetorical strategies of image-making and worshipped their mysteries under the pseudonym of "formal beauty." As a consequence, when these rhetorical strategies are actually *employed* by artists like Caravaggio or Mapplethorpe to propose spiritual or sexual submission, we are so conditioned to humbling ourselves before the cosmetic aspects of the image that we simply cannot distinguish the package from the prize, the vehicle from the payload, the "form" from the content. So now, in our culture, the scenarios of dominance by submission that characterize our participation in "high art" and "high religion" and "classical masochism" as systems of desire, all intersect in the topoi of the "arrested image," which is their common attribute, and the centerpiece of their ritual theatre. Once we acquiesce in the reification of formal values, questions of whether one manifestation is "better" than another, derives from another, is displaced by another, or transforms itself into another, become inexplicable and irrelevant.

All these scenarios, perhaps, should be considered equally redemptive and perverse, and, certainly, given the "arrested image" and the proclivity of the beholder, they are all possible—although usually, in any given context, one is more probable than the others. Images like Robert Mapplethorpe's *X Portfolio* and texts like Shakespeare's *Sonnets*, however, tilt the altars at which we worship by making them *all* seem probable. In doing so they collapse and conflate our hierarchies of response to sex, art, and religion—and, in the process, generate considerable anxiety. So we may, according to our want or desire, read *The X Portfolio* in the language of religion, of sexuality, or of formalist aesthetics, but we must do so knowing that the artist himself positioned his images exactly at their intersection. The categories are our own, and our culture's—so, finally, the images themselves, under the pressure of our categories, don't seem to be *anything* in particular. They just seem to be *too much*. And we are left asking, "Why do I submit to this gritty, baroque image of a man's arm disappearing into another man's anus? And choose to speculate upon it? And why must Robert have submitted to the actual, intimate, aromatic spectacle? And chosen to portray it? And why, finally, did the supplicant kneel and submit to having a lubricated fist shoved up his ass? And choose to have himself so portrayed?"

And the answer, of course, in every case, is pleasure and control—but deferred, always deferred, shunted upward through concentric rituals of trust and apprehension, glimmering through sexual, aesthetic, and spiritual manifestations, resonating outward from the heart of the image through every decision to expand the context of its socialization, suspending time at every point, postponing consummation, and then, suddenly—at the apogee of its suspense—swooping back down, circling rapidly inward upon an image now flickering in wintry glamour at the intersection of mortal suffering and spiritual ecstasy, where the rule of law meets the grace of trust. It is a nothing

image, really—not even an idea, but so palpably corporeal on the one hand, and so technically extravagant on the other, that it seems on the verge of exploding from its own internal contradictions. Or just disappearing when we look away.

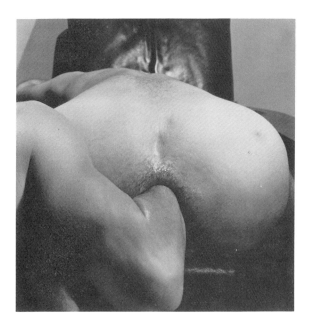

ROBERT MAPPLETHORPE
Helmut and Brooks, N.Y.C., 1978
Copyright © 1978 The Estate of Robert Mapplethorpe

37

For spirits, freed from mortal Laws, with ease
Assume what Sexes and Shapes they please.
 —Alexander Pope, *The Rape of the Lock*

Prom Night in Flatland
ON THE GENDER OF WORKS OF ART

As a step-child of the Factory, I am certain of one thing: *images can change the world*. I have seen it happen—experienced the "Before and After," as Andy might say—so I know that images can alter the visual construction of the reality we all inhabit, can revise the expectations that we bring to it and the priorities that we impose upon it—and know, further, that these alterations can entail profound social and political ramifications. So, even though I am an art critic now and occupationally addicted to the anxiety of change, I cannot forget that there should be more to it than that. Simply, there is change, and there is change; and when that previously redolent signifier takes on the innervating aspect of Brownian agitation, and that previously challenging occasion for upgrading the efficacy of one's critical practice becomes a demand to practice it as preached, one can become a bit contemplative about the whole endeavor—about connecting the dots, as it were, with regard to objects that present themselves as strategized invitations to cite those talismanic theoretical texts that inspired them in the first place.

In fact, when change stops generating anxiety by challenging one's language of value, and works of art—like still-life arrangements in a drawing studio—become simple occasions for fashionable *écrits morts*, one cannot help but cast about for explanations, nor avoid a growing sensitivity to those aspects of contemporary image-making that do not change, and which,

perhaps, make substantial (or, at least, more anxious) change less likely. For myself, I have become increasingly amazed and dismayed at the continuing persistence of dated modernist conventions concerning the canonical status of "flatness" and the inconsequence of "beauty" in twentieth-century images. In my view the linguistic properties implicit in the "negativity" of illusionistic space—its metaphorical "absence"—and the rhetorical properties latent in our largely unarticulated concept of "beauty" should more than outweigh whatever academic reservations might still accrue to them.

It was, after all, the invention of illusionistic space that bestowed upon the visual language of European culture those dimensions of "negativity" and "remote tense" that are generally taken to distinguish human languages from the languages of animals—since these properties make it possible for us to lie and to imagine convincingly in our speech, to assert what we are denying and to construct narrative memory by contextualizing our assertions with regard to a past and a future, to a conditional or subjunctive reality. For four centuries visual culture in the West possessed these options—and exploited them. Today, for some reason, we remain content to slither through this flatland of Baudelairian modernity, trapped like cocker spaniels in the eternal, positive presentness of a terrain so visually impoverished that we cannot even *lie* to any effect in its language of images— nor imagine with any authority—nor even remember. And such is the Protestant hegemony of this anti-rhetorical flatness that contemporary artists have been, in effect, forced to divert their endeavors into realms of speech, dance, text, photography, and installation design in order to exploit the semantic spaces and rhetorical felicities that are still available in literary and theatrical practice—so they might, at best, crudely approximate effects that were effortlessly available to Titian on his worst day.

This is a very peculiar situation, to say the least, and not a simple one; and so, to merely crack the lid a little, I would like to suggest in this essay that the tenacity of taboos concerning "feminine" space and "feminine" appeal derive from subliminal and largely vestigial ideas about the gender of the work of art itself (as it is characterized by the language in which we speak of it and the relationship we presume to maintain with it). Otherwise, these taboos would seem to be maintained in esteem pretty much by default, based partly on the understandable reluctance of heterosexual artists and critics to challenge them and in so doing to risk the dread charge of bourgeois "effeminacy"—since, as we know, in the Balkanized gender politics of contemporary art, the self-consciously "lovely," i.e., the "effeminate" in art, is pretty much the domain of the male homosexual. I will not digress upon this blatantly sexist (and covertly homophobic) situation except to note that it is largely validated by the patriarchal art-historical scenarios implied by etiological, high-modernist criticism like Frank Stella's *Working Space* and Michael Fried's *Absorption and Theatricality*—which, I hasten to note, are by far the best of their kind and, for what they are, very good indeed. (One may, I think, admire the subtlety and acuity of Fried's and Stella's insights into the vagaries of historical picture-making without buying into their historical agendas.)

This genre of teleological criticism inevitably portrays the "rise" of pre-modern art toward "exalted" modernism as a virile struggle with, and ultimate triumph over, the effeminacy of illusionistic space and all other devices designed to "ingratiate" the beholder. Stella addresses the "masterful" Caravaggesque inversion of passive Mannerist recession into aggressive Baroque intrusion; Fried addresses the "success" of late eighteenth-century French painters, like Greuze, Vernet, Van Loo and early David, at dropping an invisible "fourth wall" down the picture plane, chastely sealing off the erotic, participatory extravagance of Rococo space from the viewer, leaving an artist-created sim-

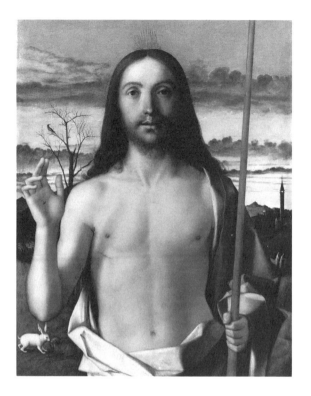

GIOVANNI BELLINI
Christ Blessing, c. 1500
Tempera and oil on wood
23-1/4" x 18-1/2"
Courtesy Kimbell Art Museum, Fort Worth, Texas

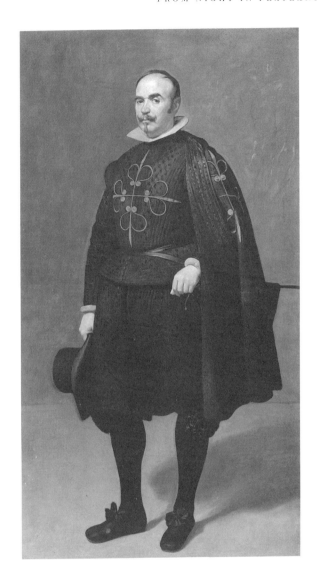

DIEGO VELÁZQUEZ
Don Pedro de Barberana, c. 1631-33
Oil on canvas
78" x 43-7/8"
Courtesy Kimbell Art Museum, Fort Worth, Texas

ulacrum of the observer inside the hermetically sealed pictorial atmosphere, thus imposing what Fried calls the "supreme fiction" that the beholder is simply not there. Fried implies, and correctly, I think, that this device is designed to cast the non-participatory viewer in the role of an "objective" moral observer. Its less redemptive by-product, unfortunately, is that it marks the dawn of surveillance—recasting the viewer in the role of an irresponsible, alienated, elitist voyeur. It is this aspect of the "supreme fiction" that Fragonard exploits so seductively in his *haut* pornography, and that Chardin, more ominously, employs to provide us with secret glimpses (through his one-way "sociological lens") of the lower orders in their most private moments.

The critical point to be made here, however, is that both Stella and Fried develop their arguments by reconstituting the traditional High Renaissance *ménage à trois* of work-artist-and-beholder. At its most sophisticated, this sixteenth-century dynamic of perception assumed a bond of common education, religion, and gender (male) between the artist and the beholder. If anything, the artist was regarded as the less entitled of this duo, but conventionally, at least, these two comrades were presumed to stand side-by-side confronting the "otherness" of the work's rapidly receding pictorial space, evoking both the prospect of heavenly Arcadia and the mystery of the "erotic other." So the invitation of the open picture plane is offering both a window into spiritual succor and the prospect of a "heavenly cunt" (*potta del cielo*) to the beholder, who might gain access via the blessed virgin or the symbolic maidenhead according to his Neoplatonic proclivity.

This simultaneous maintenance of spiritual and carnal senses in works of art is, of course, a crucial aspect of the free-wheeling Renaissance resolution of Classical and Christian antiquity. It enabled the Renaissance artist to exploit both the secular corporeality of Classical imagery and the theological imper-

atives associated with the doctrine of the "incarnate word" (the word made flesh). Without the redemption of this perpetual double-entendre and its invitation to covert reading, of course, Ovid would have been blasphemous, Raphael a little dull, and Bernini's *Saint Theresa* all but inexplicable. With it, what we call "modern art" is all but impossible.

So, in Stella and Fried, this *ménage* of work-artist-and-beholder is reconstituted. The bond of commonality between artist and beholder is dissolved by the artist's prophetic singularity, and along with it the presumption that both artist and beholder have equal insight into the covert mysteries of the work. "Strength" is now ascribed to a work of art in terms of its bond with the artist; "weakness" is detected in terms of its bond with its beholder. (Insofar as I have been able to determine, the word "strength" as it is used in contemporary criticism is a straightforward euphemism for the medieval concept of "virtue," a gender-sensitive term of approbation denoting virility and power in men and chastity and composure in women; by analogy, the term "weakness" as it is used in this criticism implies effeminacy in men and promiscuity in women.) In this restructured dynamic, the function of the beholder is to be dominated and awestruck by the work of art, which undergoes a sex-change and is recast as a simulacrum of the male artist's autonomous, impenetrable self.

This reconstituted *ménage* is also reflected by a shift in the cautionary mythology of artistic creation. By the end of the eighteenth century, the traditional myth of Pygmalion (whose romantic involvement with the "otherness" of his creation engenders a secular equivalent of the miracle of the incarnate word) has been superseded by that of Mary Shelley's *Frankenstein*. Pygmalion's erotic nymph is now replaced by Dr. Frankenstein's monster—a powerful, autonomous simulacrum of its creator's promethean, subterranean self, wreaking cold judgment and vengeance on all who behold it. It is not insignificant, I think, that

the dominant female member of the circle of English romantics would be the first of them to explicate the darker side of their conception of the work of art as a radical, autonomous creature of the alienated self.

Under these revised priorities, then, the validity of receding illusionistic space in painting was immediately called into question. This imaginary space had been traditionally, and quite rightly, perceived as "community property" shared by the work and its artist/beholder. The new, modern priorities insisted that no such community existed, and thus, the flat picture plane came to represent the property line dividing the mundane world of lesser beings from the exalted territory of the artist's incarnate prophecy. Thus, when Stella celebrates Caravaggio's retailoring of the traditional *ménage à trois* into a *pas de deux*, he credits the artist with transforming his studio into a "cathedral of the self." In doing so, of course, he also voices his silent disapproval and dismissal of a large tradition of artists like Warhol, Tiepolo and the generous Boucher who risked the charge of frivolous effeminacy by transforming *their* studios and their art into promiscuous confluences of the "other."

Of course, from an artist's point of view, this exclusive, elitist bonding of artist and work might seem a wholesome state of affairs. From the point of view of a professional beholder like myself (whose job is establishing "relationships" with works of art), it is somewhat less so. Insofar as Stella's and Fried's historical reflections accurately mirror the character of contemporary art (and to a large extent they do), I may almost certainly expect, as I walk into a gallery, to confront either a bunch of autonomous icons pretending that I am not present, or a covey of "difficult" autodidacts intruding into my space and making theoretical demands on me. After years of such confrontations, it has become increasingly clear to me that our twentieth-century characterizations of the work of art as this ravishing, autonomous entity that we spend our lives trying to understand, that makes

demands on us while pretending we are not there, is simply a recasting of the work of art in the role of the remote and dysfunctional male parent in the tradition of the Biblical patriarch. Even art critics deserve some respite from this sort of abusive neglect.

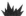

Anyway, it should be clear by now that the nature of what I am arguing here is twofold. Firstly, I am suggesting that over the last four-hundred-odd years, the "work of art," as we characterize it, has undergone a number of gender shifts, so that the cultural demotic that, in Vasari's time, invested works of art with attributes traditionally characterized as "feminine"—*beauty, harmony, generosity*, etc.—now validates works with their "masculine" counterparts—*strength, singularity, autonomy*, etc.— counterparts which, in my view, are no longer descriptive of conditions. Secondly, I am suggesting that the dynamics of these gender shifts presuppose that the gender of the artist and the beholder are *not* shifting, which of course they are. This fact would seem to invite a more radical rethinking of the gender dynamics inherent in our perception of historical art than any of us probably have time for.

Further, I should like to be clear on two other issues. First, the question of whether these antique "feminine" qualities are still extant in works of art is not really at issue here. Of course they are. They are simply no longer validated by our language of value. As such they remain *verbally invisible* and therefore accidental to any determination we might make in "serious" discourse about the virtues of the work. This condition, of course, contributes mightily to the disingenuous relationship between criticism and the marketplace at the present time. There can, in fact, be no resolution between a language of criticism devoted to principles of abstract speculation and a market which functions by virtue of perceived relationships between human beings and

works of art. Second, the question of whether these two sets of traditional attributes are "really" masculine or feminine is beside the point as well. Even if it's true (as it seems to me to be) that these traditional antinomies have more to do with our changing conceptions of power and entitlement than with any so-called "fact" of biological gender, it is this traditional fiction of gender that informs real behavior, and not my revisionist concept of it.

And so, for me at least, the consideration of the gender of works of art raises a complex of aesthetic and moral issues that I would like to just hint at by describing part of a walk though the Kimbell Art Museum in Fort Worth, Texas. Principally, I am interested in the radical change of moral climate one experiences walking from the room of sixteenth-century pictures into the room of seventeenth-century pictures, leaving a room hung with, among other things, Bellini's *Christ Blessing* and Titian's *Madonna and Child with Saint Catherine,* and entering a room hung with Caravaggio's *The Cardsharps*, La Tour's *Cheat with the Ace of Clubs*, Murillo's *Four Figures on a Step*, an El Greco cleric, a Velázquez soldier, and Ribera's *Saint Matthew.*

The first thing you notice, of course, walking from room to room is the picture plane turning around. That sixteenth-century "window looking out" spins upon its axis into a seventeenth-century "window looking in." Recession is replaced by foreshortening, "feminine" space replaced by "masculine" intrusion, and that Renaissance invitation out of the real, through the picture plane and into the possibility of ideal mercy, is replaced by the Baroque intrusion of secular power, by images whose icy naturalism demands to be perceived as *more real,* more authoritative than the reality in which you stand. So your role as the viewer is radically altered: You were the *beholder* in the sixteenth-century room—the welcomed guest invited by Christ and the Madonna into this remote, Arcadian *potta del cielo* receding beyond them. Upon entering the seventeenth century, you become the *beheld*—held in place outside the space of the paint-

ings by the authority of glance and illusion. You stand in the dock before the elevated figures of Ribera's saint, El Greco's cleric, and Velázquez's policeman, all of whom stare ruthlessly down upon you. Beyond them, there is no mysterious appeal, no refuge or respite, only darkness.

Even the genre pictures in the seventeenth-century room insist upon your original sin, your guilt and complicity. The space of Caravaggio's *Cardsharps* extends into the room where you stand, placing you next to the table, making you an intimate witness and accessory to a deception you can do nothing about. The same is true of La Tour's *Cheat with the Ace of Clubs*, with the additional fillip that the cheat is glancing out of the picture plane, nailing you with that Baroque glance in your complicity. In Murillo's *Four Figures on a Step*, the entire picture pivots upon the implied intentions of the viewer who stands, in effect, in the street gazing at a pimp, his whore and an old woman who sullenly presents the backside of her child to the viewer in an obvious tableau of procurement. The viewer is forced into the role of lascivious purchaser, locked in place by the complex invitations in the gazes of the man and the two women.

What interests me in the radical climatic shift between these two rooms of splendid pictures is that the shift of formal gender from "feminine" to "masculine" space is accompanied by a congruent shift of gender-related moral concerns as described by Carol Gilligan in her two books on this subject, *In Another Voice* and *Mapping the Moral Domain*. Early in her career as a psychologist, Gilligan confronted the fact that most psychological research into the nature of human value judgments had been conducted with male subjects. Over the past decade, then, Gilligan and her colleagues have worked to redress this imbalance, and in the process they have discovered that men and women in our culture address moral issues from two distinctively different perspectives. Men, she discovered, tend to make judgments based on what Gilligan calls a morality of

"judgment" derived from ideas of abstract justice and based on a hierarchy of values and responsibilities aimed at respecting the separation and radical autonomy of the individuals involved. Women, on the other hand, even when they arrive at the same conclusions, tend to base their decisions on what she calls the morality of "care" deriving from a vision of human interdependence, human need, shared values, communication, and the possibility of nurture.

I find this distinction interesting for a number of reasons. Firstly, of course, Gilligan's description of the morality of judgment provides a fairly accurate model for the canon of most twentieth-century art and criticism in its hierarchical emphasis on autonomous non-communication. Secondly, Gilligan's distinction between the morality of care and the morality of judgment almost exactly describes the change of climate between the sixteenth- and seventeenth-century rooms in the Kimbell Museum. And this elegant shift in the antique moral climate should remind us of the extent to which the ideologies of care and autonomy manifest themselves today as care *for* autonomy, in a malignant *folle à deux* in which toxic "feminine" care is extravagantly expended upon toxic "masculine" autonomy. Thus the culture itself has made an industry of swaddling untold legions of unyielding and ungenerous artifacts in the garments of crippling professional nurture.

Place Velázquez's soldier and Bellini's Christ face-to-face and you would have the entire dialectic visualized: the necessity of judgment facing the possibility of mercy, the elegance of autonomy facing the generosity of beauty, the hard foreground of controllable fact facing the mystery that dissolves into the distance, beyond our control. Somewhere between them, I insist, lies a richer reality, a better language, a more complex sense of community, and a more courageous art. Something more than the inarticulate, intransitive flatland of the picture plane.

The judicial distinction between contract and institution
is well known: the contract presupposes in principle the
free consent of the contracting parties and determines
between them a system of reciprocal rights and duties;
it cannot affect a third party and is valid for a limited
period. Institutions, by contrast, determine a long-term
state of affairs which is both involuntary and inalienable;
. . . it tends to replace a system of rights and duties by a
dynamic model of action, authority and power.
—Gilles Deleuze, "Coldness & Cruelty"

After the Great Tsunami

ON BEAUTY AND THE
THERAPEUTIC INSTITUTION

The subject here is "beauty"—not what It is but what it does—
its rhetorical function in our discourse with images. Secondarily,
the subject is how, in the final two-thirds of this century, we have
come to do without it, and how we have *done* without it by reas-
signing its traditional function to a loose confederation of
museums, universities, bureaus, foundations, publications, and
endowments. I characterize this cloud of bureaucracies generally
as the "therapeutic institution"—although other names might do.
One might call it an "academy," I suppose, except that it upholds
no standards and proposes no secular agenda beyond its own
soothing assurance that the "experience of art" under its politi-
cally correct auspices will be redemptive—an assurance founded
upon an even deeper faith in "picture-watching" as a form of
grace that, by its very "nature," is good for both our spiritual
health and our personal growth—regardless and in spite of the
panoply of incommensurable goods and evils that individual
works might egregiously recommend.

It goes without saying, I suppose, that this therapeutic
institution is a peculiarly twentieth-century artifact, but to under-
stand just *how* peculiar, we need to ask ourselves: What other
century since the Dark Ages could sustain an institution man-
dated to kidnap an entire province of ongoing artistic endeavor
from its purportedly dysfunctional parent culture?—with the
purported intention of "rescuing" that endeavor from the political

and mercantile depredations that produced it? None, I would suggest. And yet, after centuries of bureaucrats employing images to validate, essentialize, and detoxify institutions—to glorify their battles, celebrate their kings, and publicize their doctrines—we have, at last, in this century, an institution to validate, essentialize, and detoxify our *images*—to glorify *their* battles, celebrate *their* kings, and publicize *their* doctrines—and, of course, to neutralize their power. It should come as no surprise, then, that this therapeutic institution came into being in the aftermath of the greatest flowering of unruly images in the history of man, at the conclusion of the longest sustained period since the Renaissance during which institutional and pedagogical control over the arts could be considered nominal at best.

As we know, these gaudy, speculative images were borne forth like blossoms on a great tsunami of doubt and spiritual confusion that swept majestically through the late nineteenth century, cresting into the twentieth and almost immediately exploding across Europe in a conflagration of wars and revolutions. By the nineteen twenties, however, answers were available again, and assurances against doubt and confusion, and there were men in power to embody them. So, quite sensibly, these new ideological elites began to reassert control. In the Soviet Union, Stalin's cultural commissars began legislating the absolute subordination of form to content in the name of the proletariat. In the United States, Alfred Barr, in the service of inherited capital, proclaimed the absolute subordination of content to form; while in Germany, in the name of the Nazi bourgeoisie, Reichsminister Joseph Goebbels, the brightest and wickedest of them all, was orchestrating their perfect match. Different agendas to be sure, but almost simultaneously, each of these three *putsches* consolidated and activated the powers of patronage to neutralize the rhetorical force of contemporary images—to minimize the slippage, as it were, between how it looks and what it means, because, as long as nothing but "the

beautiful" is rendered "beautifully," there is no friction—and things do not change.

The preëmptive Fascist appropriation of Futurist rhetoric in Italy, of course, was a different political animal altogether, although it speaks to the same slippery issue of private rhetoric and public power. As it turned out, Mussolini's coup would not meet its match until the early nineteen sixties when Ivy League Cold Warriors in Washington coöpted the cultural chauvinism of Abstract Expressionism, mounting touring exhibitions that effectively converted Pollock's canvases into muscular, metaphorical billboards for a virile, imperial, "allover" America.

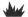

Today, naturally, the rhetorical nature of the discourse is hardly debatable. If we accept the contemporary axiom that the meaning of a sign is, indeed, the response to it, then there is every reason to regard works of art as rhetorical instruments rather than philosophical entities—or essential copies. Further, in a legalistic culture like our own—in which the status of the image has been problematic since Moses came down the mountain, and all great visual artifacts from the Sistine Chapel to *Blue Poles* are occasions for disputation rather than consent—a certain amount of inverse variability between how it looks and what it means is, I think, taken for granted. Under the waning aegis of the therapeutic institution, however, the consequences of this slippage remain unexamined.

Freud, in fact, puts his finger on this inverse variable between how it looks and what it means in his essay "Creative Writers and Daydreaming." Here, Freud characterizes the artist's task as the covert fulfillment of socially unacceptable infantile wishes in which we acquiesce on account of "the purely formal—that is, the aesthetic—yield of pleasure which he [the artist] offers us in the presentation of his phantasies. We give the name of

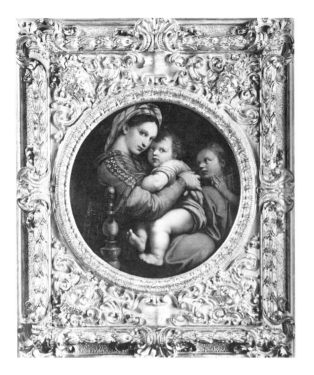

RAPHAEL
Madonna della Sedia
[Madonna of the Chair], c. 1514
71 cm diameter
Pitti Palace, Florence
Courtesy Alinari/Art Resource, NY

incentive bonus, or *forepleasure,* to a yield of pleasure such as this, which is offered to us so as to make possible the release of still greater pleasure arising from deeper psychical sources." Freud, of course, by characterizing our "formal" pleasure as "pure," presumes that the rhetorical aspects of a work's presentation are somehow distinguishable from its more radical content, and further, that they somehow mitigate it. I would suggest that, far from ameliorating the artist's radical, infantile wishes, the rhetoric of beauty *politicizes* them, makes them publicly available, and proposes them in fact as social options. Further, I would suggest that Reichsminister Goebbels understood this, as did Alfred Barr, and Stalin—and that none of them was particularly sanguine at the prospect.

This is not to say, of course, that art is just advertising, only that art, outside the institutional vitrine of therapeutic mystery, is never *not* advertising and never apolitical. Commodity advertising and pornography only define the limiting conditions of art's project, its objective and somatic extremes, but they participate, just like the real thing, in that accumulated shifting, protean collection of tropes and figures that comprise "the rhetoric of beauty." And in fact, since these marginal endeavors exist outside the purchase of the therapeutic institution, they continue to employ that powerful rhetoric to sell soap and sex, constructing images in which the figures of beauty function as they always have in the visual discourse of European culture. First, they enfranchise the beholder by exhibiting markers that designate a territory of shared values, thus empowering the beholder to respond. Second, they valorize the content of the image, which, presuming its litigious or neurotic intent, is in need of valorization.

The unfashionable implication of this characterization is that rhetorical beauty, as we are considering it, is largely a *quantitative* concept. It proposes to enfranchise *numbers* of individuals. However, since the rhetoric can, on occasion, perform

one of its functions more efficiently than the other, some dis-
tinctions can be made. We can, for instance, distinguish between
the "most beautiful image" that simply enfranchises the most
people, and the "most *effective* beautiful image" that valorizes
the most preposterous (oops, problematic) content to the most
people for the longest time. Raphael's *Madonna of the Chair*
would qualify here, for its having exquisitely valorized the "iffy"
doctrines of the incarnate word and the virgin birth to genera-
tions of Catholics worldwide who should have known better.

Further, we might say that the "most *efficient* beautiful
image" is that which valorizes the most egregious content to the
wealthiest, most powerful and influential beholders exclusively;
and in this category, I think we must acknowledge Picasso's *Les
Demoiselles d'Avignon*—a painting that we must regard either as
a magnificent "formal breakthrough" (whatever that is) or, more
realistically, as a manifestation of Picasso's dazzling insight into
the shifting values of his target market. I mean this seriously.
Consider this scenario: Pablo comes to Paris, for all intents and
purposes, a bumpkin, complete with a provincial and profoundly
nineteenth-century concept of the cultural elite and its proclivi-
ties—still imagining that the rich and silly prefer to celebrate
their privilege and indolence by "aestheticizing" their immediate
environment into this fine-tuned, fibrillating, pastel *atmosphere*.
He proceeds to paint his Blue and Rose period pictures under this
misapprehension (pastel clowns, indeed!)—then Leo and Ger-
trude introduce him to a faster crowd.

He meets some rich and careless Americans and, grad-
ually, being no dummy, perceives, among the cultural elite with
whom he is hanging out and perilously hanging on, a phase-shift
in their parameters of self-definition. These folks are no longer
building gazebos and situating *symboliste* Madonnas in fern-
choked grottos. They are running with the bulls—something that
Pablo can understand—and measuring their power and security
by their ability to tolerate high-velocity temporal change, high

levels of symbolic distortion, and maximum psychic discontinuity. They are *Americans*, in other words, post-Jamesian Americans, in search of no symbolic repose, unbeguiled by haystacks, glowing peasants, or Ladies of Shallot. So Pablo Picasso—neither the first nor the last artist whom rapacious careerism will endow with acute cultural sensitivity—goes for the gold, encapsulates an age, and, through no fault of his own, finally creates the cornerstone of the first great therapeutic institution.

I have no wish to diminish Picasso's achievement by this insouciant characterization of it, but I do want to emphasize the fact that, at this time, pictures were made primarily *for* people, not against them—and to suggest that if we examine the multiplication of styles from roughly 1850 to 1920, we will find, for each one of them, a coterie of beholders, an audience already in place. Thus, a veritable bouquet of styles, of "beauties," were invented, *and none of them died*, nor have they ever. An audience persists for all of them; and, if I seem to have splintered the idea of beauty out of existence by projecting it into this proliferation of "beauties," well, that is more or less my point.

For nearly 70 years, during the adolescence of modernity, professors, curators, and academicians could only wring their hands and weep at the spectacle of an exploding culture in the sway of painters, dealers, critics, shopkeepers, second sons, Russian epicures, Spanish parvenues, and American expatriates. Jews abounded, as did homosexuals, bisexuals, Bolsheviks, and women in sensible shoes. Vulgar people in manufacture and trade who knew naught but romance and real estate bought sticky Impressionist landscapes and swooning Pre-Raphaelite bimbos from guys with monocles who, in their spare time, were shipping the treasures of European civilization across the Atlantic to railroad barons. And most disturbingly for those who felt they ought to be in control—or that *someone* should be—"beauties" proliferated, each finding an audience, each bearing its own little rhetorical load of psycho-political permission.

It is no wonder, then, that the cultural elites in Europe and America would take the occasion of the Great Depression—while all those vulgar folks in trade were so ignominiously starving—to reassert their control over a secular culture run rampant. They did so blandly in Paris and Bloomsbury, violently in Moscow and Berlin, and ever so elegantly in New York, where a brilliant young gentleman managed to parlay his tandem passions for contemplating little brown pictures and dining with rich old women into a *Museum* of Modern Art. It was an historic moment, a watershed, to say the least, so it is not surprising, perhaps, that a great deal of the art that Alfred H. Barr Jr. appropriated from the rich, *Reichsminister für Volksaufklarung und Propaganda* Joseph Goebbels found inappropriate for the *volk*—a fact which should pique our suspicion as to whether Barr's institutionalization of this work doesn't betray his own elitist reservations about the appropriateness of these images, in unredeemed condition, for the *volk*. At any rate, both Barr and Goebbels, having acquired institutional power, proceeded with roughly parallel agendas—both of them clearly operating out of an understanding that works of art, left to their own audiences, have the potential to destabilize the status quo.

Barr, operating from the premise that art can be good for us, selected the art that he considered "best" for us, and emphasized by text and juxtaposition those aspects of the art he thought signified their quality. So, if one had attended Barr's opening exhibition of works by Cézanne, Gauguin, Seurat, and van Gogh, it would have been clear that Barr was hypostasizing their rhetorical aspects into "formal values," and recommending these artists to us for their rather narrow area of regional and technical convergence, while suppressing their equally self-evident and candidly disparate social, political, and philosophical agendas.

Goebbels, on the other hand, selected the art that he considered "worst" for us to exhibit in *Entartete Kunst*. He then emphasized, by text and juxtaposition, those aspects that he

thought signified their degeneracy. These turned out to be a lot of the same qualities that Alfred Barr thought signified quality, but not to worry: one curator reifies the rhetorical aspects of the work, another vilifies them. As long as institutional control is reasserted and the rhetorical aspects of beauty are neutralized, what's the difference? Well, obviously, our relationship to images is different. Our relationship to images authorized by beauty is now distinct from our relationship to images authorized by the therapeutic institution, and radically so. And this is no less the case when a single image undergoes a shift of authorization, as anyone who has loaned work to a museum exhibition can tell you. Visiting that work can be like visiting an old friend in prison. It is a distinctly different image, hanging among a population of kindred offenders, bereft of its eccentricity and public franchise, yet somehow, on account of that loss, newly invested with a faintly ominous kind of parochial power. To suggest the nature of this distinction, I would like to draw some analogies between these relationships and those discussed by Gilles Deleuze in his essay of 1967, "Coldness and Cruelty."

In this essay, Deleuze seeks to unpack the portmanteau concept of sadomasochism, and to dissolve the presumed reciprocity that Freud infers between sadism and masochism; and, if one is willing to accept Sade and Masoch as exemplars of the idioms that bear their names, he does so quite successfully— returning to their texts and elegantly delineating their contrasting content. Most crucially, Deleuze argues that, although both Sade's and Masoch's narratives portray persecutors and victims, and both exploit the sexual nexus of pleasure and pain, there is no reason to contrapose them. Similar narratives do not necessarily tell similar stories, nor versions of the same story. In narratives of desire, it matters *whose* story it is, who writes the script and who describes the scene—who deter-

mines whose fate and who controls the outcome. When these factors are taken into account, the dramas of Sade and Masoch diverge into different dimensions, generating distinct and profoundly dissonant envionments.

Masoch tells the victim's story and only his. In Masoch, it is the *victim* who recruits the cast, describes the scene, and scripts the action. And, ultimately, by negotiating the conditions of his own servitude and "educating" his persecutor, Masoch's victim dominates the scene of his submission and derives from it a yield of pleasure. Sade, on the other hand, tells the master's story, always, and *his* script is presumed to have the philosophical force of reason, the authority of nature. Sade's masters ruthlessly impose the logic of their natural philosophy upon unwilling victims, alternately "instructing" them in its rigor and scientifically describing for us its technical application.

As a consequence, the mechanisms of these two narratives depart at every point. The sadist has no insight into masochism, nor any need of a masochist. He requires an unwilling victim whom he can degrade and "instruct." Likewise, the masochist has no need, nor any understanding, of the sadist. He requires a willing mistress whom he can elevate and "educate." Sadism is about the autonomous act. (Sade narrates actions.) Masochism is about theatrical suspense. (Masoch "freezes the scene.") Sadism is about nature and power. Masochism is about culture and, ironically, the law. Finally, sadism deals with the imposition of "formal values" and the cruel affirmation of "natural law," and masochism focuses on deferred sublimity and the vertiginous rhetoric of trust. As a consequence, Deleuze notes, "the sadist is in need of institutions," and "the masochist of contractual relations."

The analogy I wish to draw here is blatant. The rhetoric of beauty tells the story of the beholder who, like Masoch's victim, contracts his own submission—having established, by free consent, a reciprocal, contractual alliance with the image. The

signature of this contract, of course, is beauty. On the one hand, its rhetoric enfranchises the beholder; on the other hand, it seductively proposes a content that is, hopefully, outrageous and possible. In any case, this vertiginous bond of trust between the image and the beholder is private, voluntary, a little scary, and since the experience is not presumed to be an end in itself, it might, ultimately, have some consequence.

The experience of art within the therapeutic institution, however, *is* presumed to be an end in itself. Under its auspices, we play a minor role in the master's narrative—the artist's tale—and celebrate his autonomous acts even as we are off-handedly victimized by their philosophical force and ruthless authority. Like princes within the domain of the institution, or jailhouse mafiosi, such works have no need of effeminate appeal. And we, poor beholders, like the silly *demimondaines* in Sade's *Philosophy of the Bedroom,* are presumed to have just wandered in, looking for a kiss, so *Pow!* Whatever we get, we deserve—and what we get most prominently is ignored, disenfranchised and instructed. Then told that it is "good" for us.

Thus has the traditional, contractual alliance between the image and its beholder (of which beauty is the signature, and in which there is no presumption of received virtue) been supplanted by an hierarchical one between Art, presumed virtuous, and a beholder presumed to be in need of it. This is the signature of the therapeutic institution. And although such an institution, as Barr conceived it, is scarcely imaginable under present conditions, it persists anyway and even flourishes—usually in its original form, but occasionally under the administration of right-thinking creatures who presume to have cleansed its instrumentality with the heat of their own righteous anger and to be using its authority (as the Incredible Hulk used to say) as a "force of good."

This is comic-book thinking. Nothing redeems but beauty, its generous permission, its gorgeous celebration of all

that has previously been uncelebrated. And if we entertain, even for a moment, the slightest presumption that an institution, suddenly and demonstrably bereft of its social and philosophical underpinning, is liable to imminent collapse, we have committed what George Bernard Shaw considered the most suicidal error that a citizen can. As Shaw pointed out, institutions collapse from lack of funding, they do not die from lack of meaning. *We* die from lack of meaning.